NATURE VISTAS
COLORING BOOK

JEREMY ELDER

DOVER PUBLICATIONS, INC.
MINEOLA, NEW YORK

This beautiful coloring collection features flora and fauna from all over the world, ranging from underwater landscapes, great desert expanses, forest wildlife, and more. Part of Dover's *Creative Haven* series for the experienced colorist, thirty-one finely-detailed plates are perfect for experimentation with a variety of color and media techniques. Plus, the perforated pages make displaying your finished work easy!

Bibliographical Note

Nature Vistas Coloring Book is a new work,
first published by Dover Publications, Inc., in 2016.

International Standard Book Number

ISBN-13: 978-0-486-79742-7
ISBN-10: 0-486-79742-2

Manufactured in the United States by RR Donnelley
79742202 2016
www.doverpublications.com

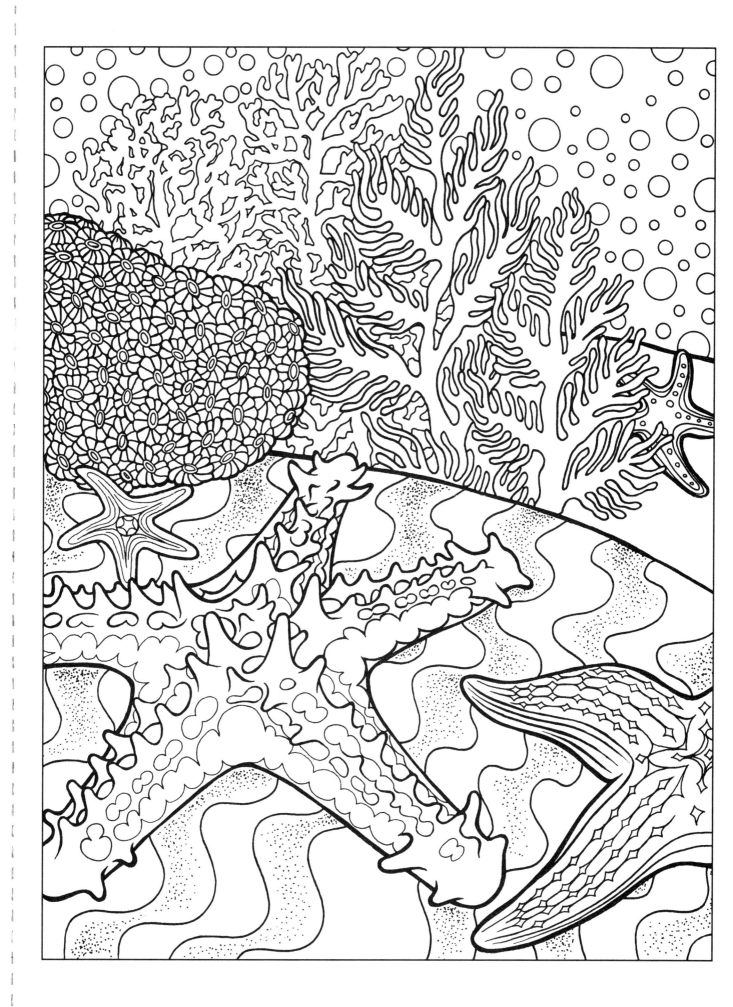

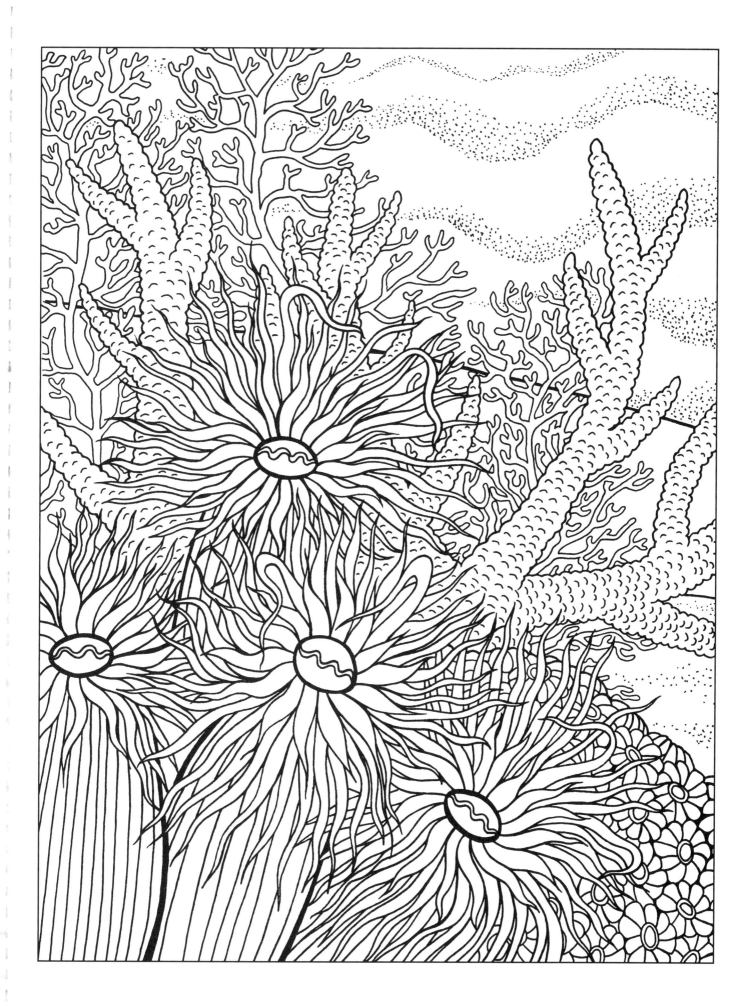

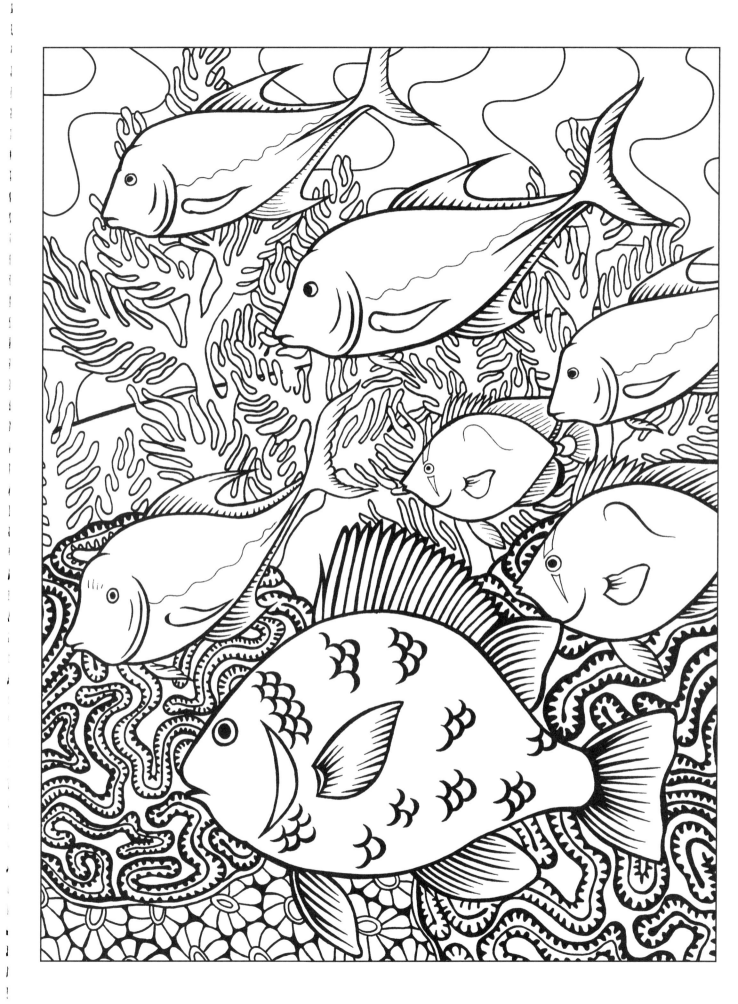

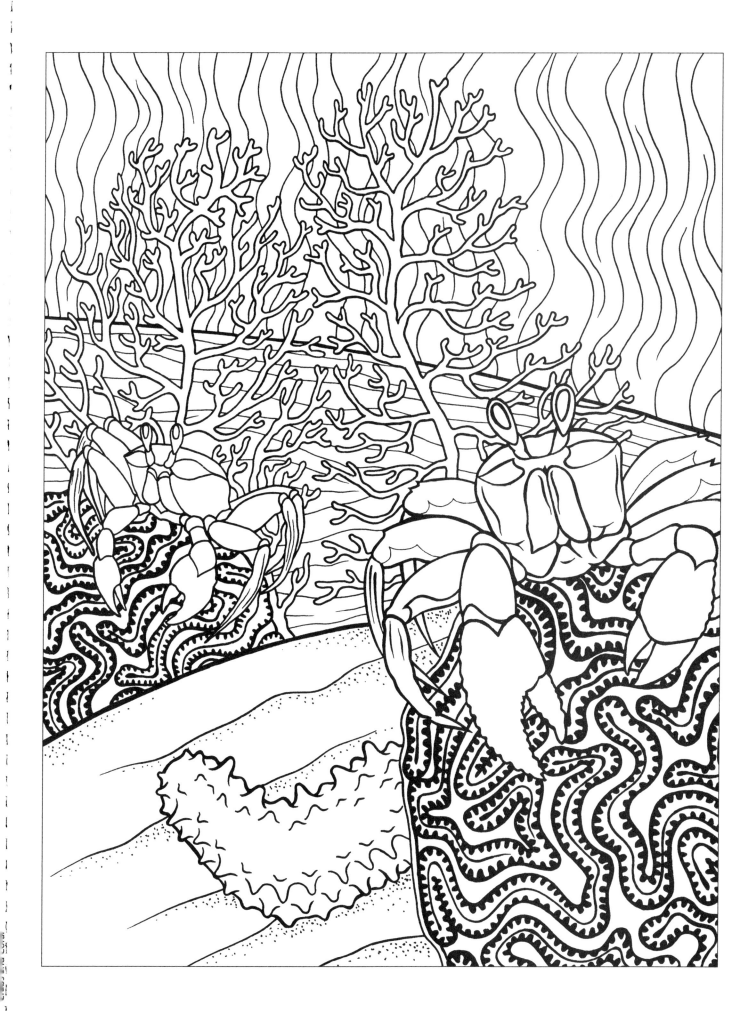

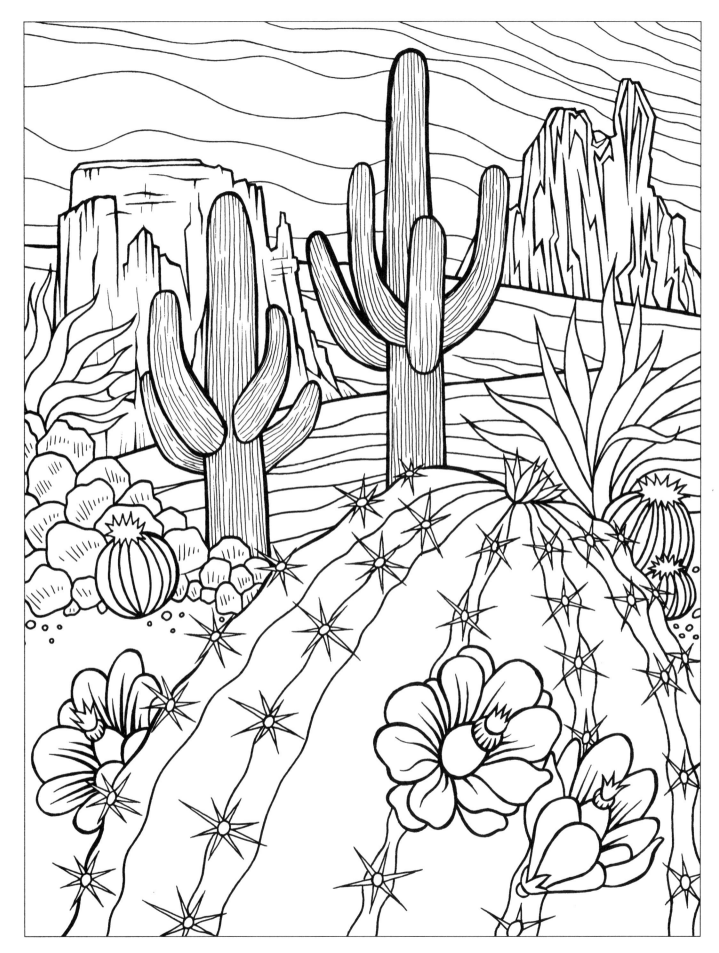

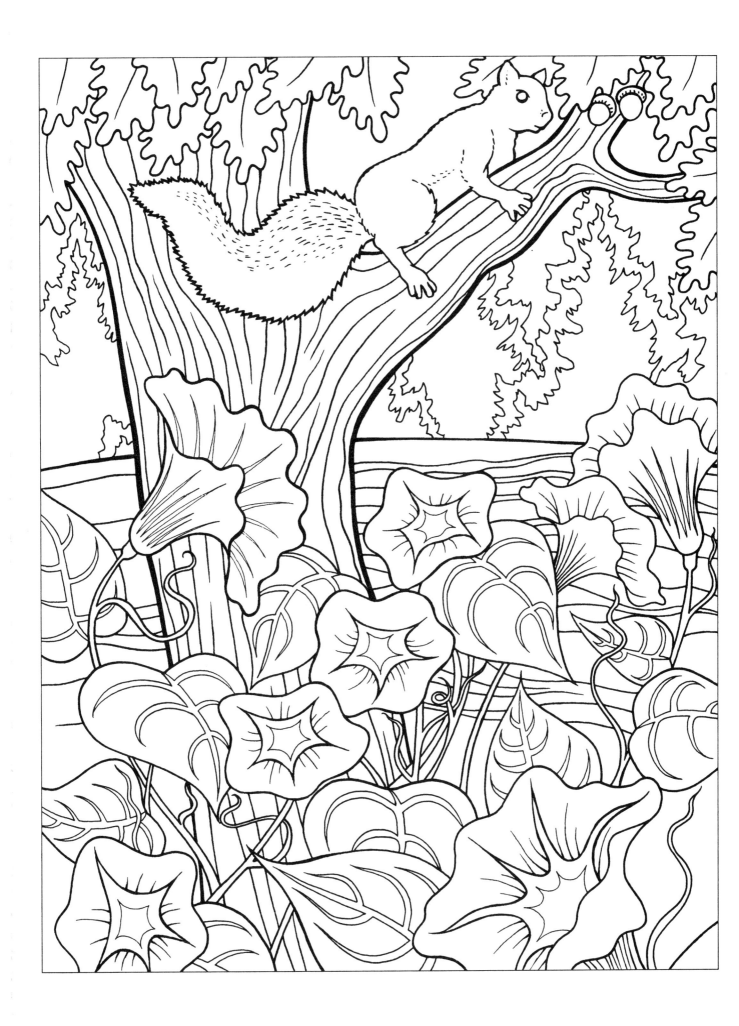

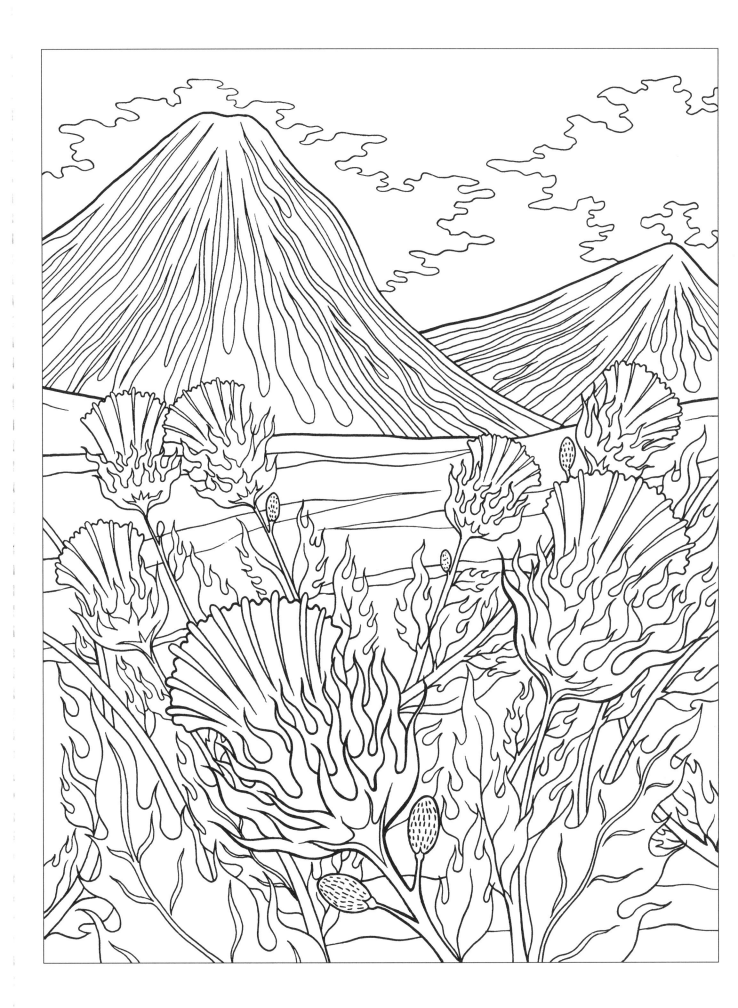

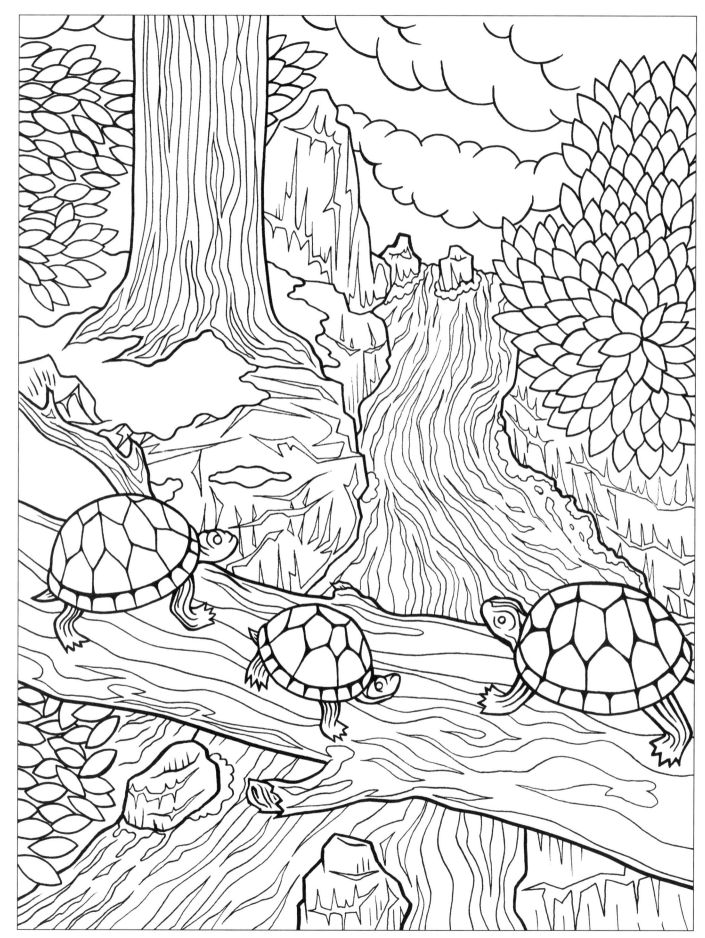

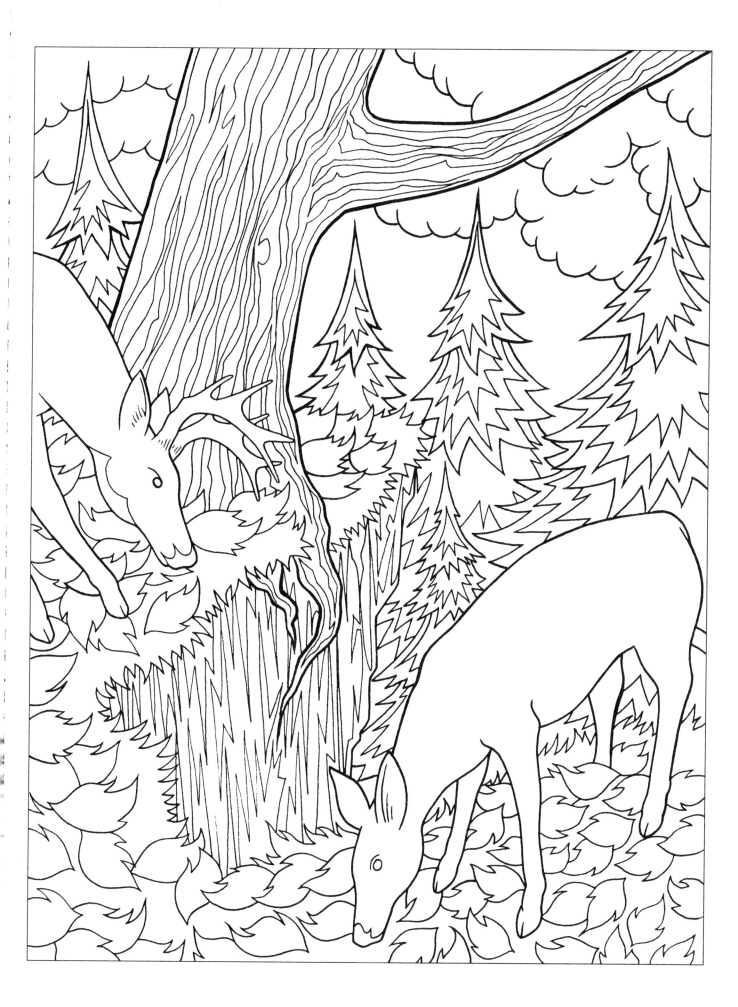

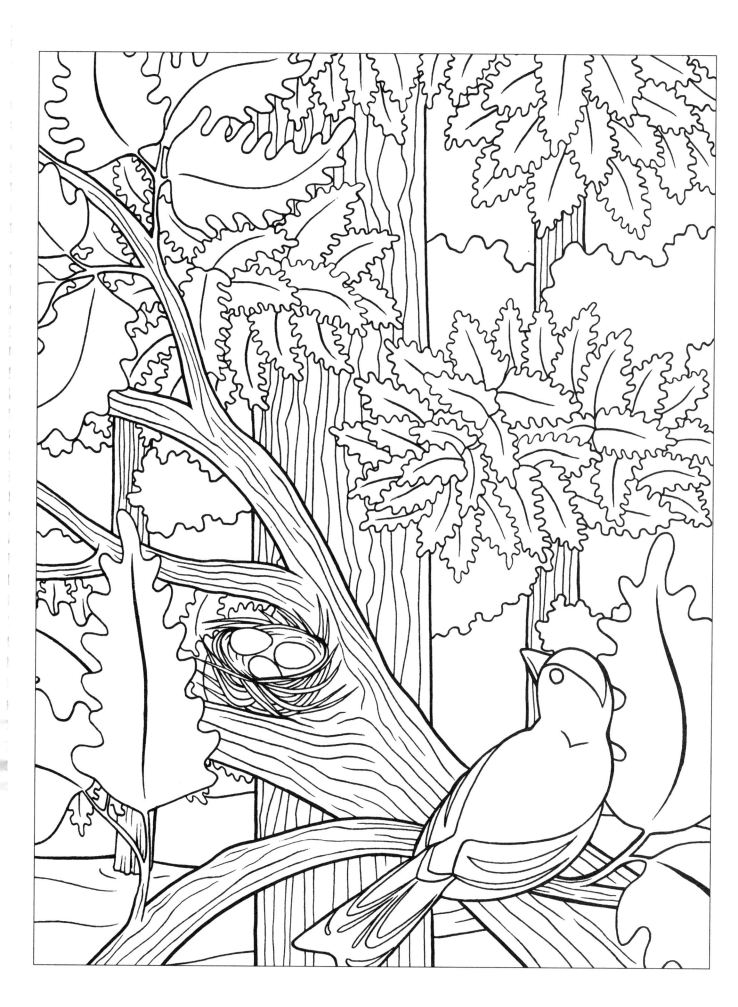

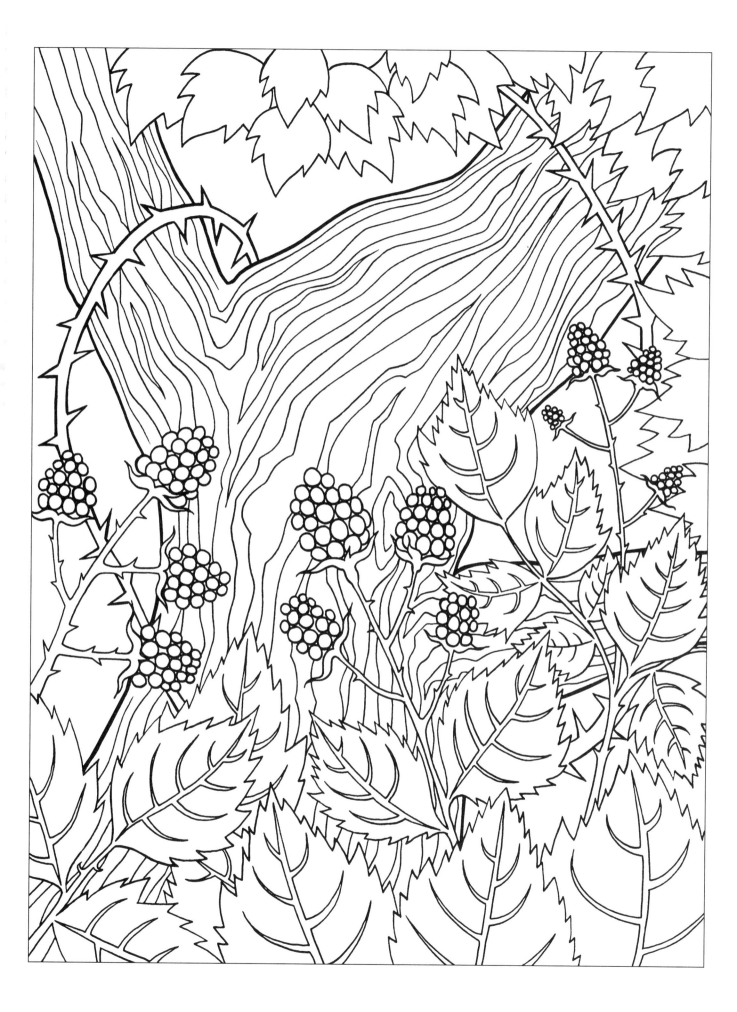

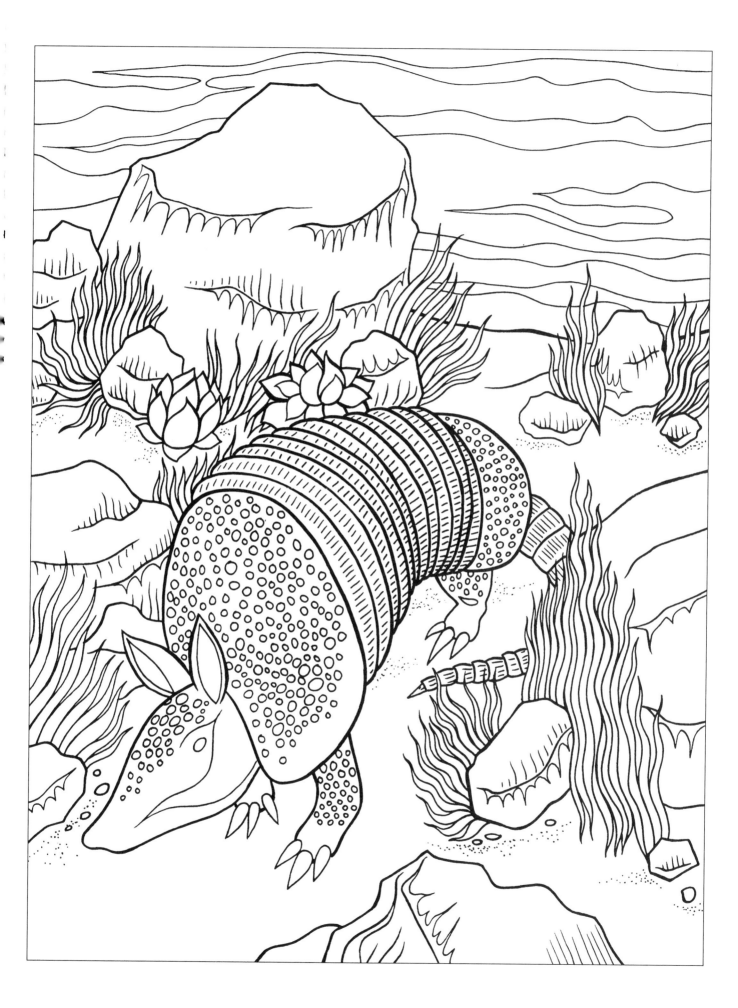

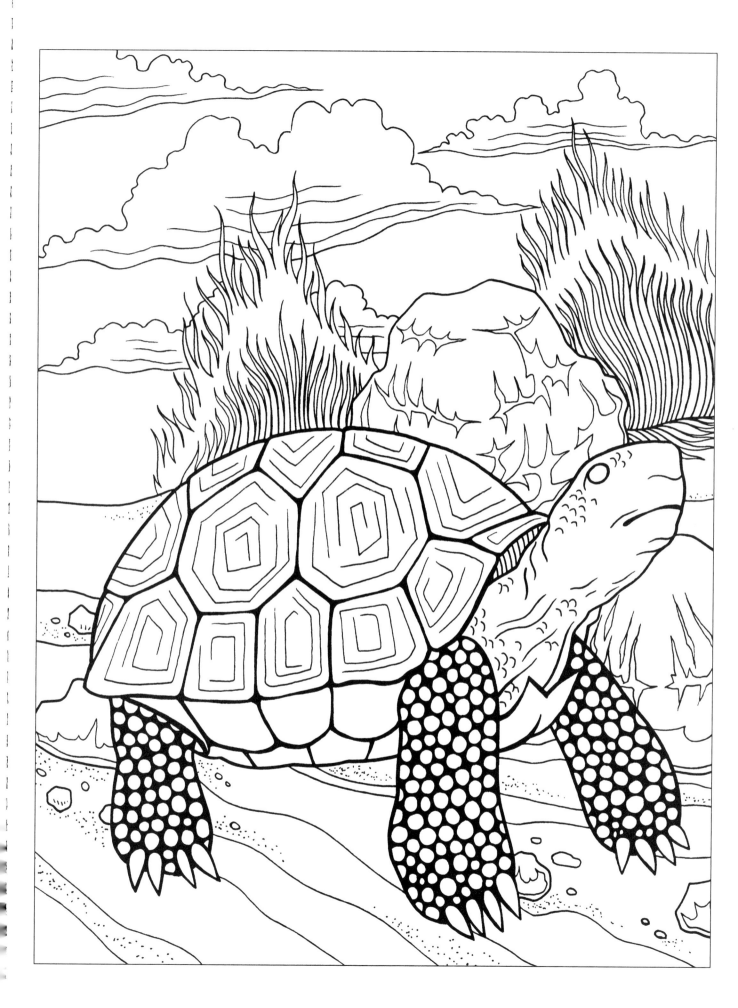

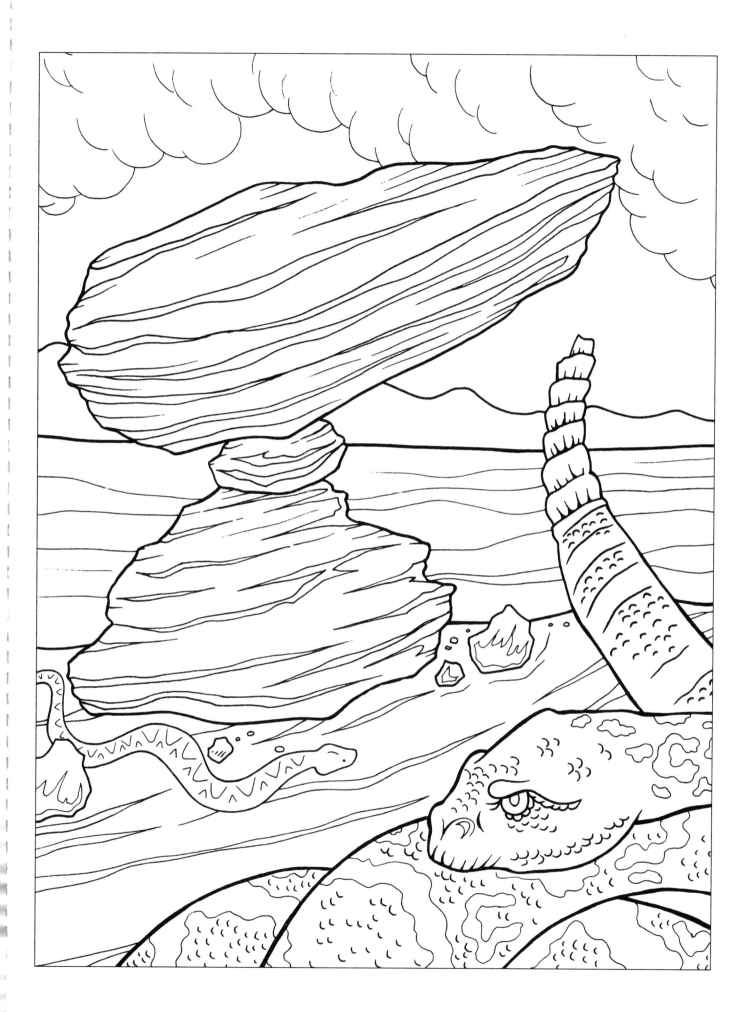

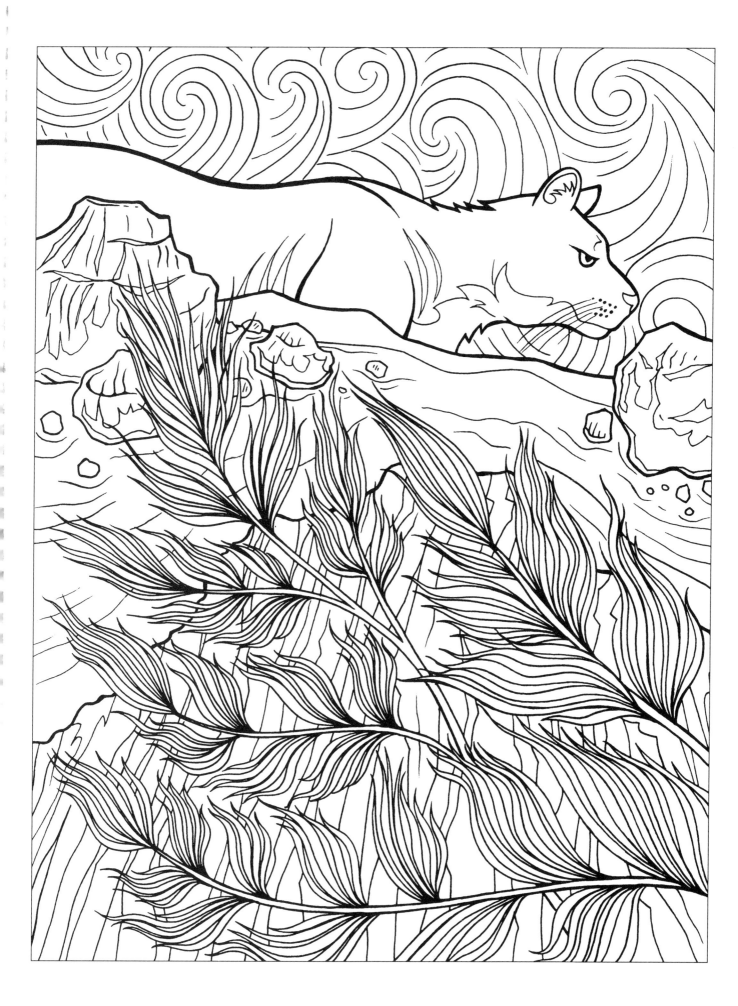

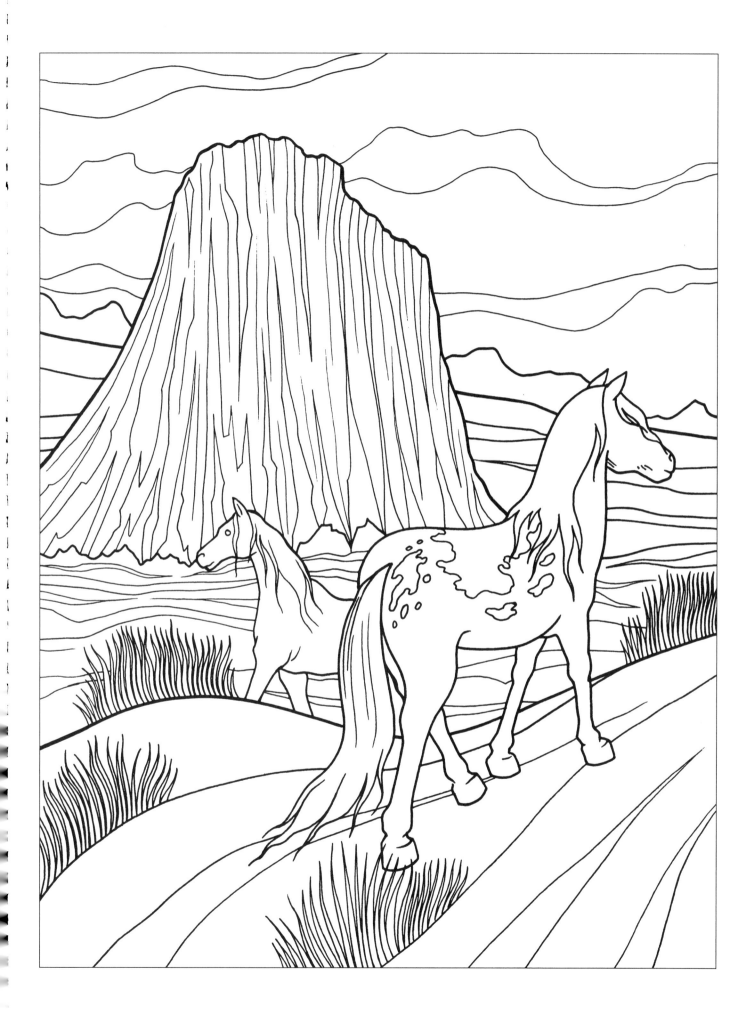

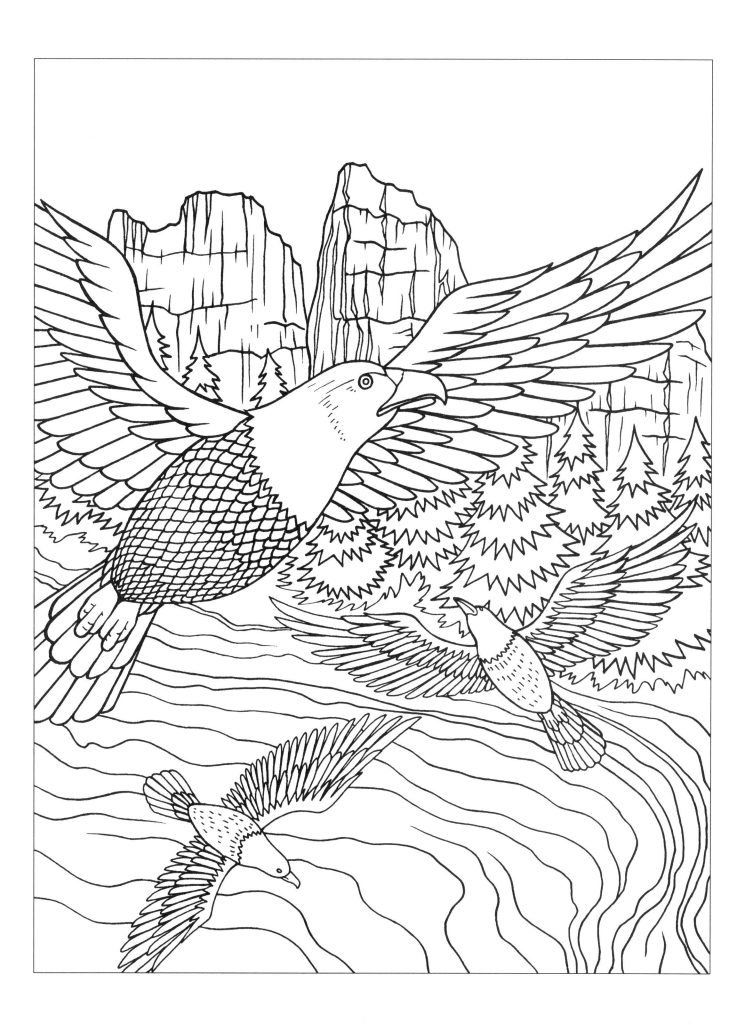

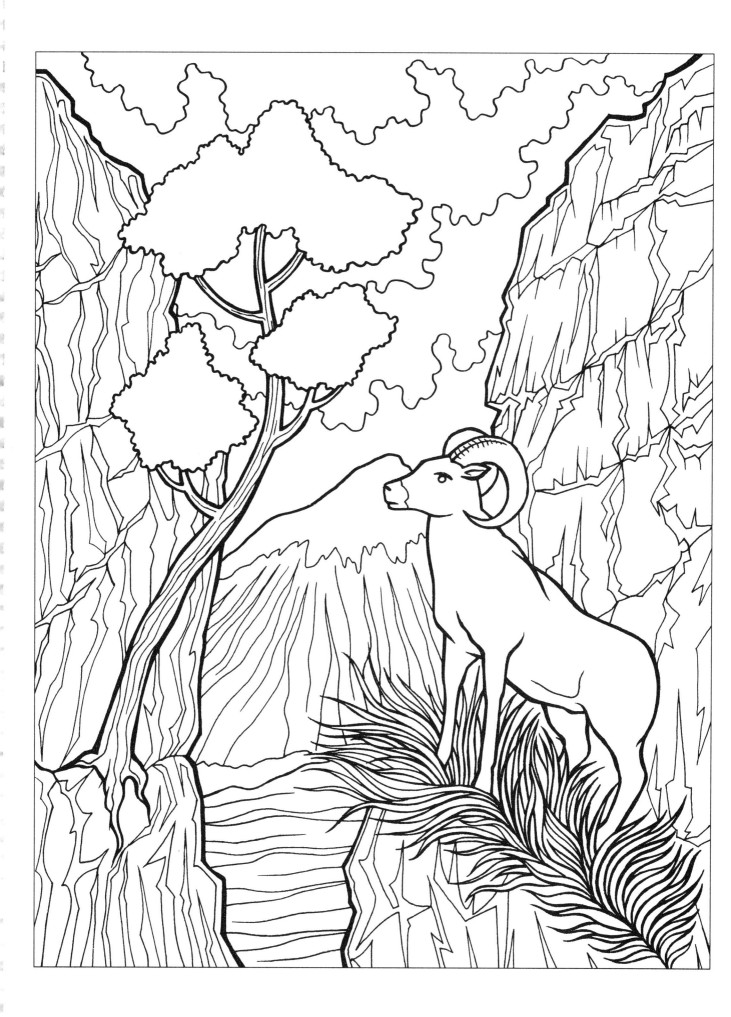

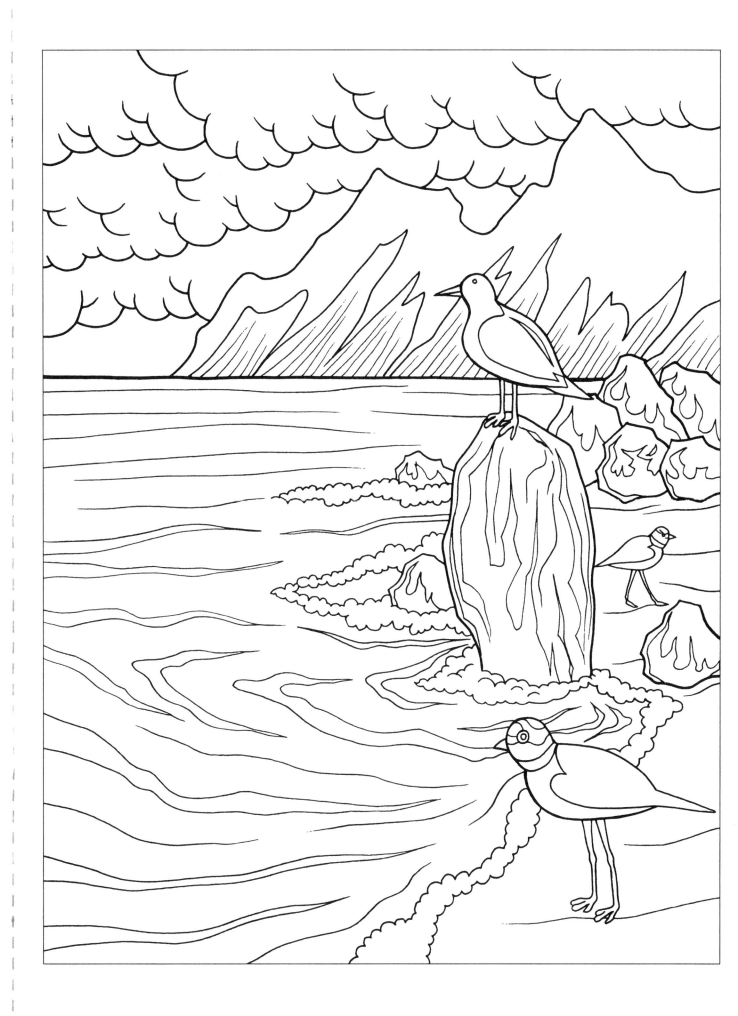

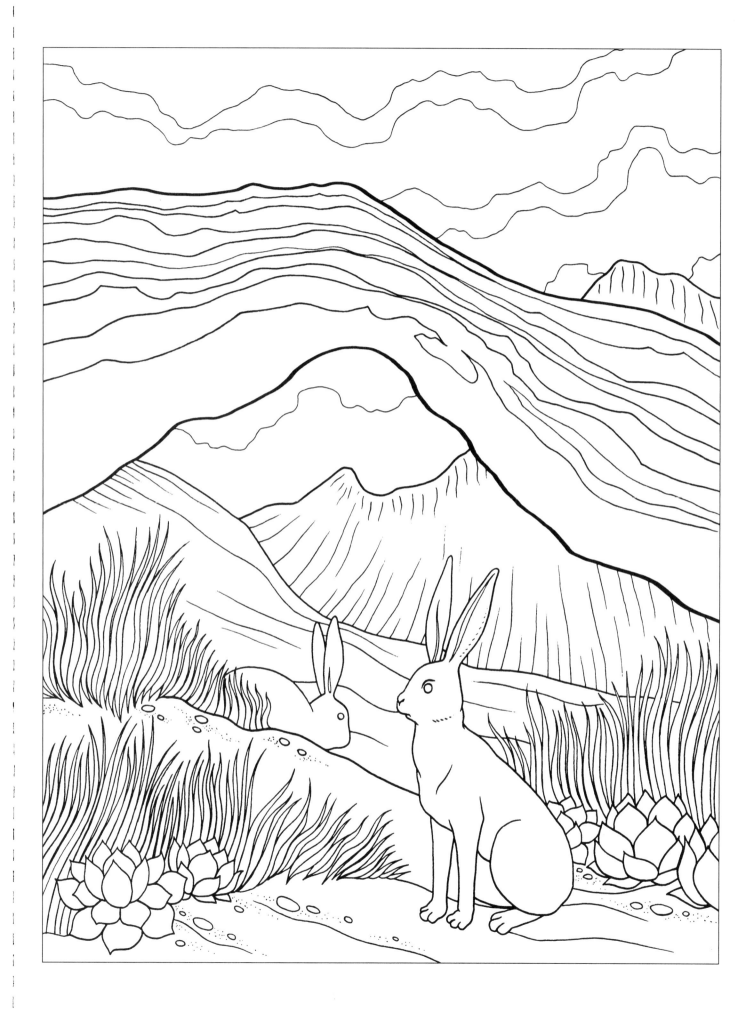

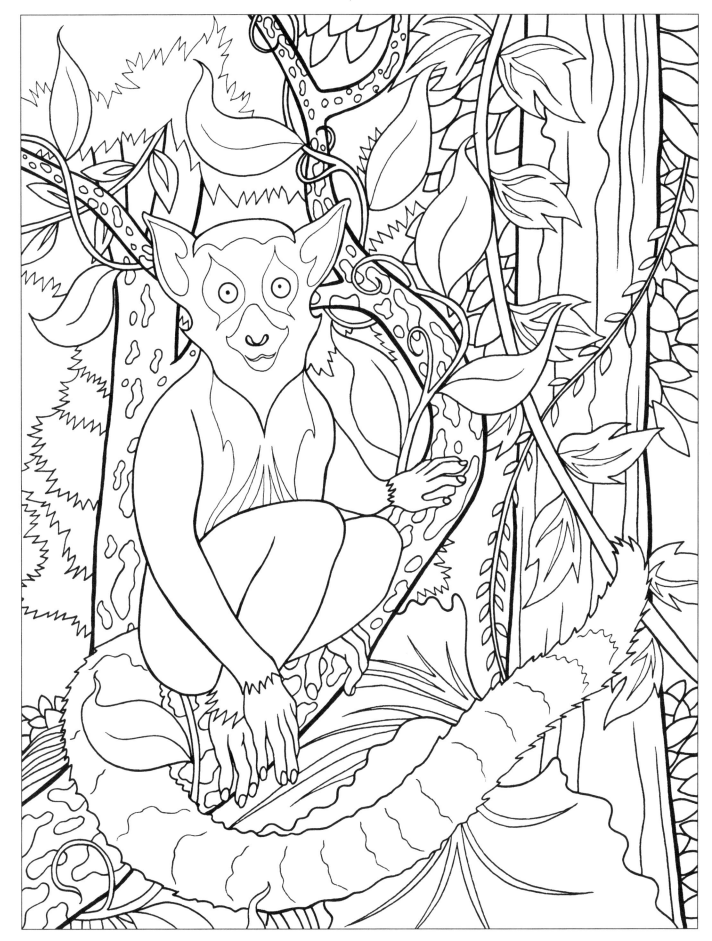

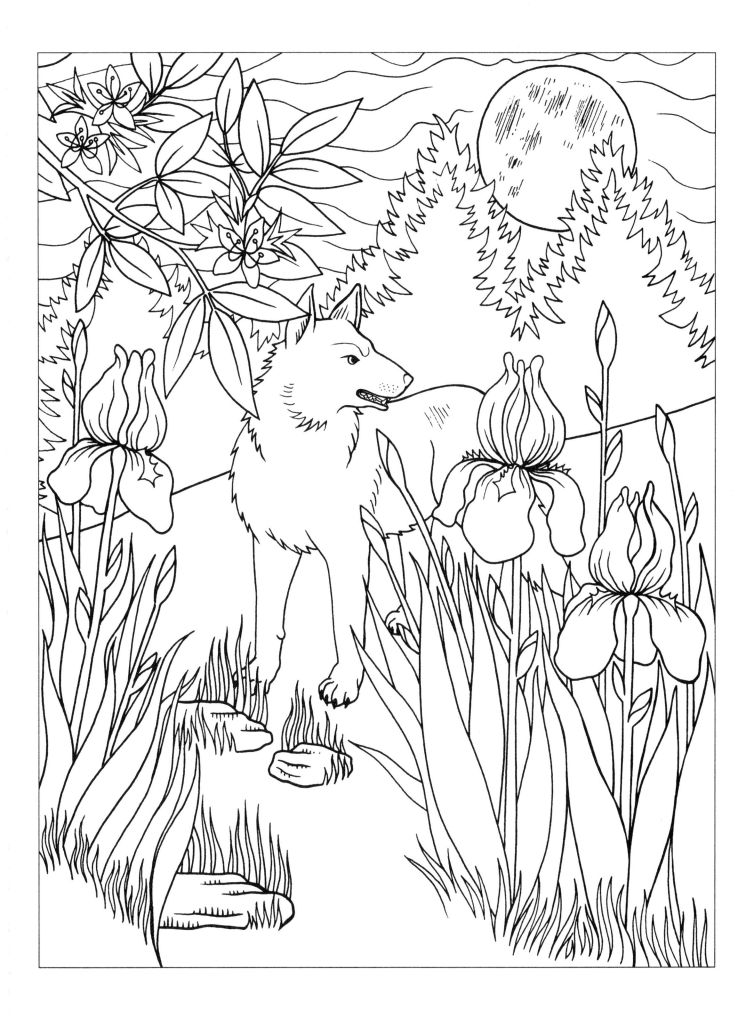

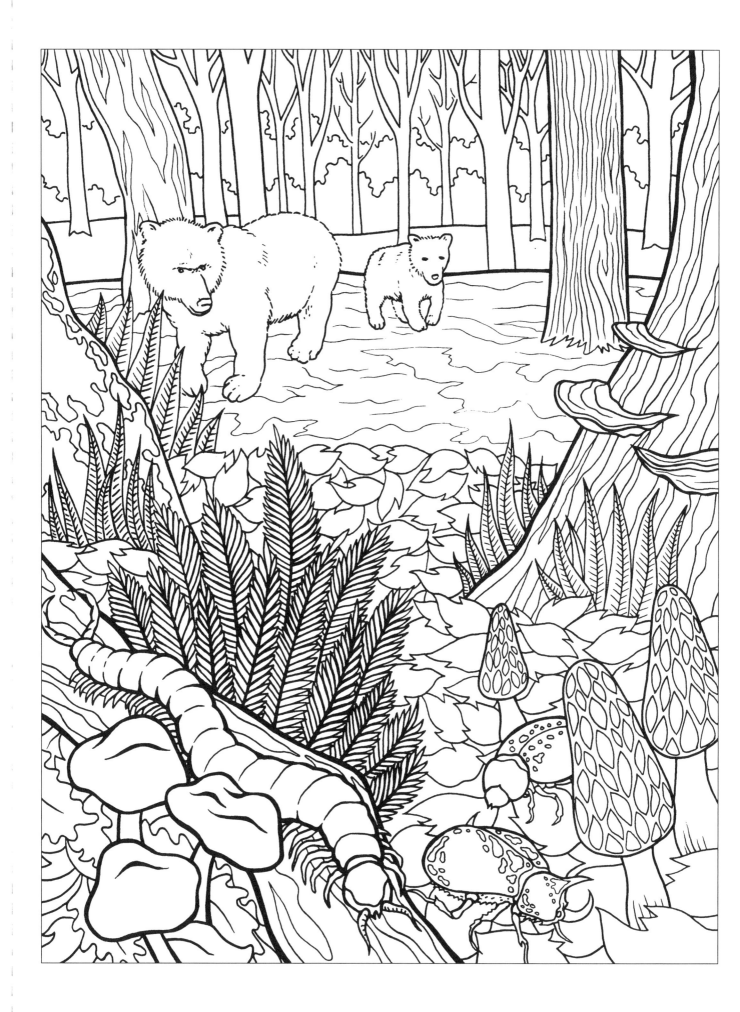

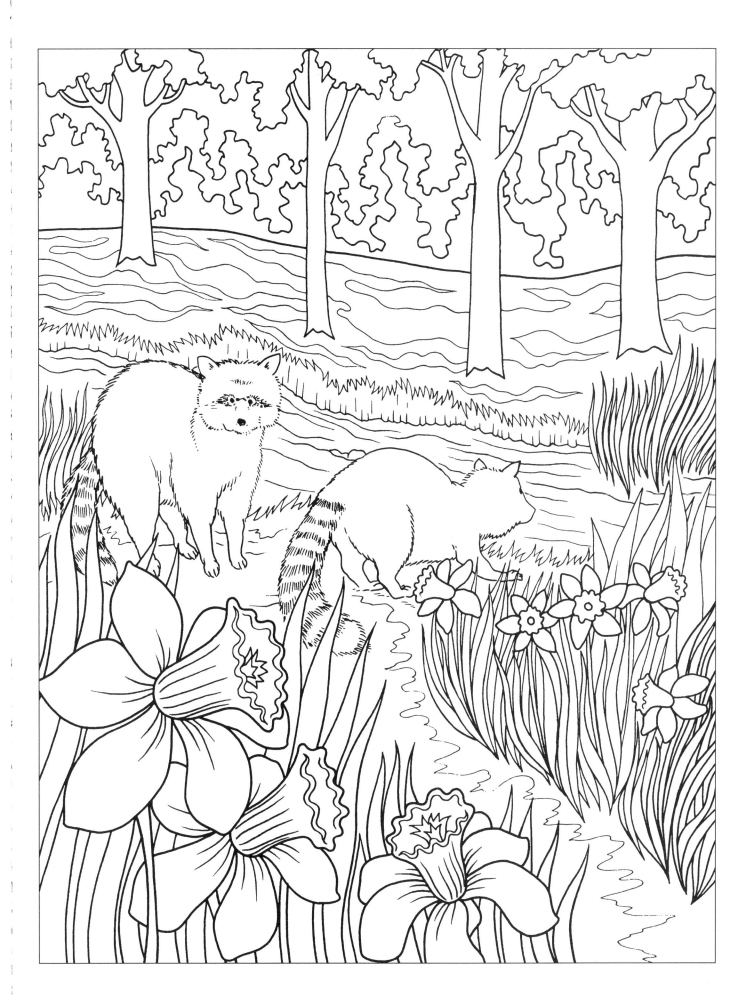

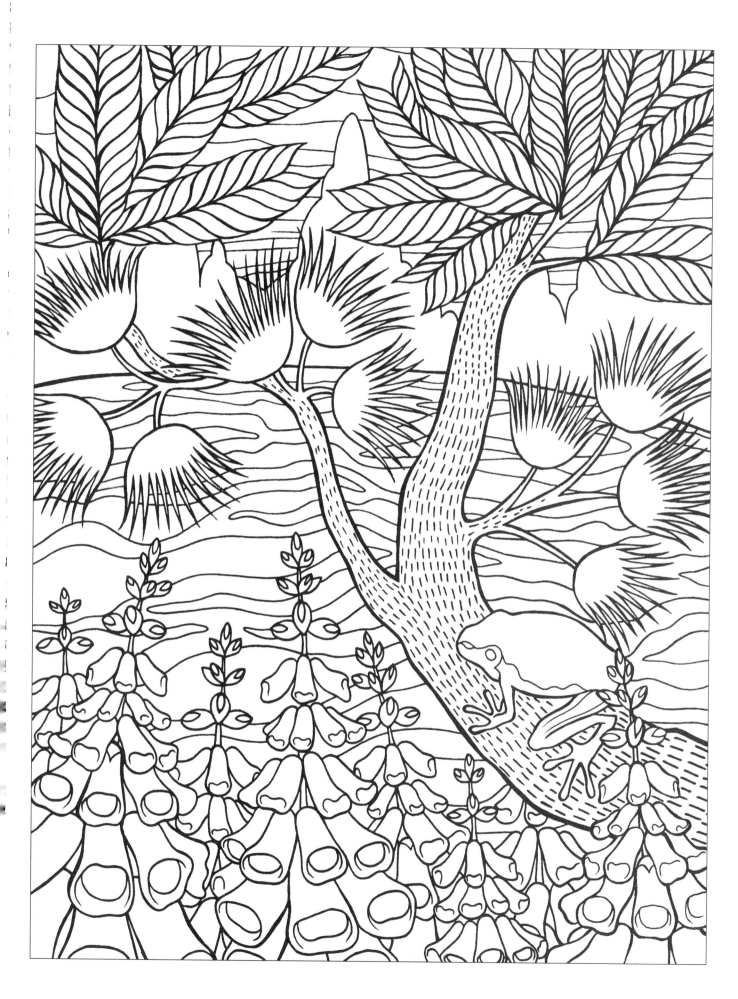

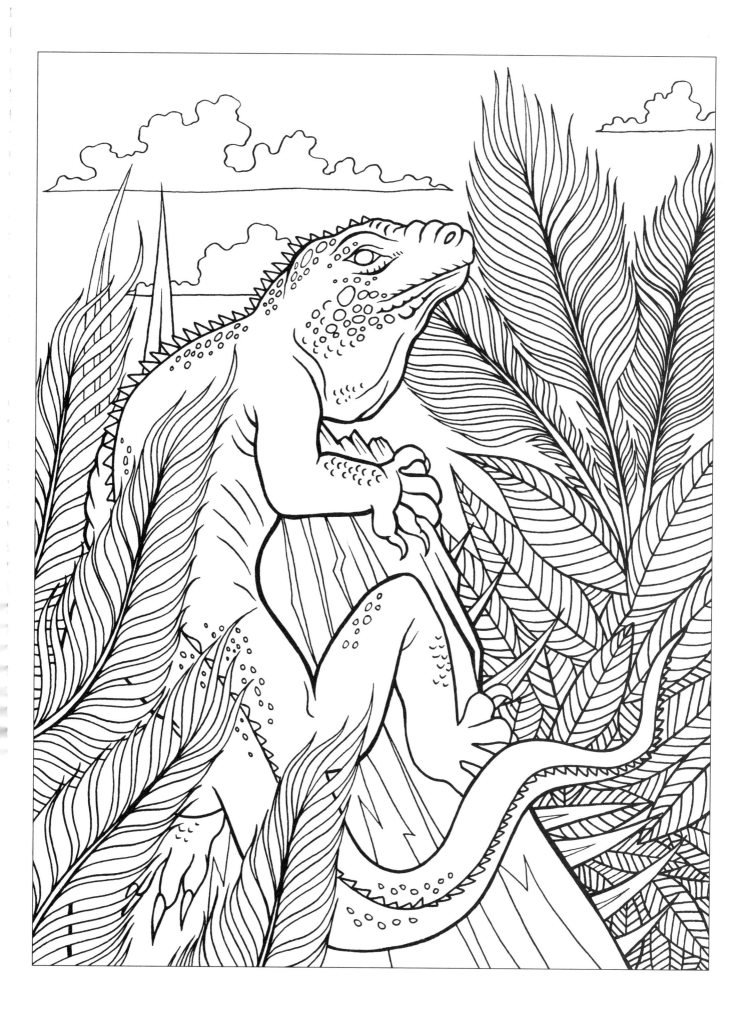

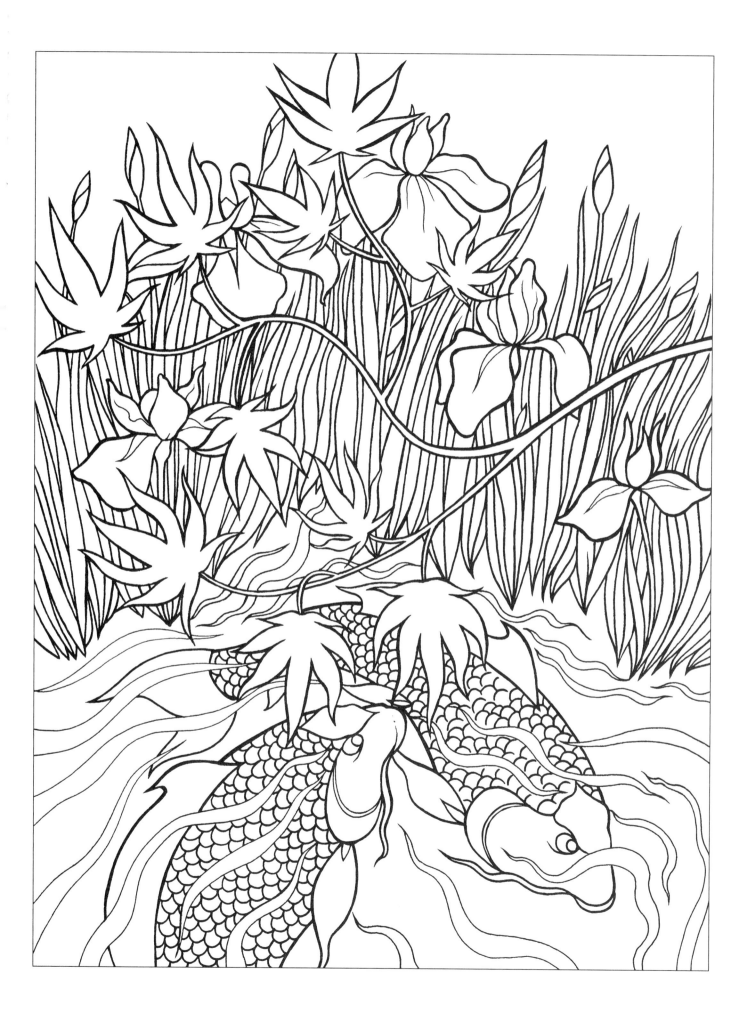

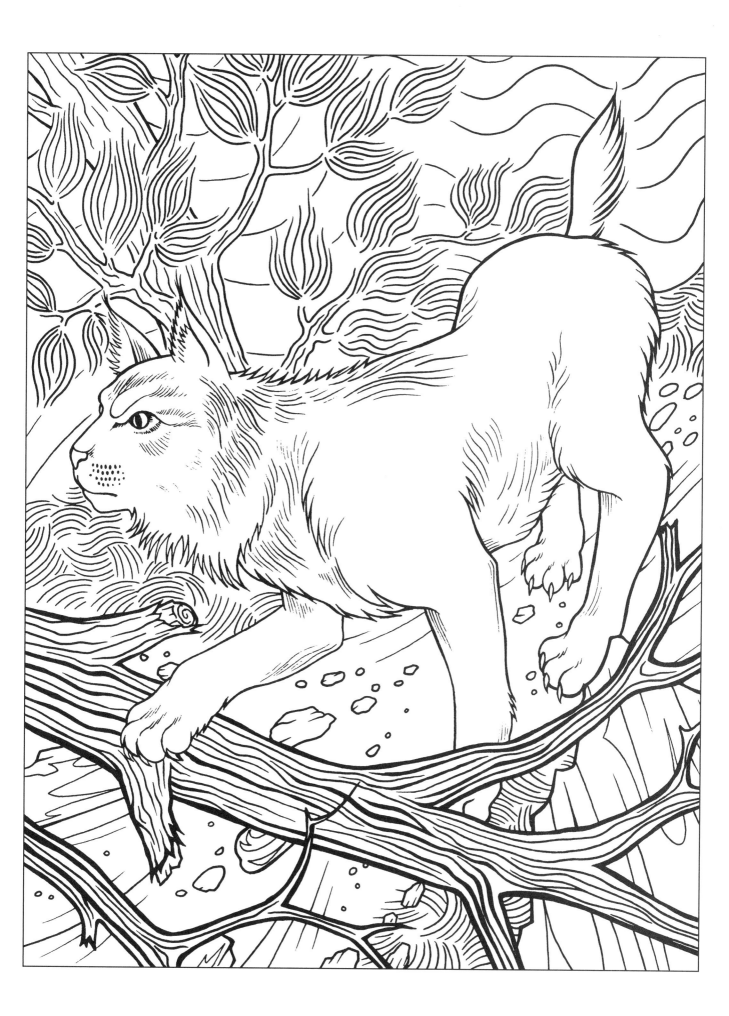